Dogs Smiling for Dog Reasons

waggish

**GRACE CHON &
MELANIE MONTEIRO**

The Countryman Press
A division of W. W. Norton & Company
Independent Publishers Since 1923

To Vin, Jasper, and smiling dogs everywhere.
—GC

To my dog of a lifetime,
the eternally waggish and beautiful Taiga.
—MM

For information about special discounts for bulk purchases, please contact W. W. Norton Special Sales at specialsales@wwnorton.com or 800-233-4830

Manufacturing by Toppan LeeFung
Book design by Nick Caruso Design
Production manager: Devon Zahn

The Countryman Press
www.countrymanpress.com

A division of W. W. Norton & Company, Inc.
500 Fifth Avenue, New York, NY 10110
www.wwnorton.com

978-1-68268-098-8

10 9 8 7 6 5 4 3 2 1

CONTENTS

Ten years ago, I was a stressed-out art director working at an advertising agency. It was supposed to be my dream job, yet there I was, a miserable and workaholic wreck. It was at this moment in my life that I ended up adopting a street dog from Mexico named Maeby. Adopting her was one of the best decisions I've ever made. If we're being honest, I had found my soul mate.

Maeby's sweet smile was better than anything else I could have turned to after a horrible day at the office. Suddenly working on ad campaigns felt meaningless when all I wanted to do was spend time with dogs. I bought a camera and started taking headshots of other rescue dogs to help them get adopted. My volunteer work evolved into a bustling pet photography business, and nine months later, I quit my job in advertising to become a full-time pet photographer. The rest, as they say, is history.

For nearly a decade now, I've devoted my life to capturing the faces and personalities of thousands of pets. While I love all God's creatures, great and small, dogs will always be my favorite. Their loyalty, faithfulness, and unconditional love have filled a million tiny holes in my heart that I never knew existed.

I'm now convinced there is no better therapy than a tail-wagging, butt-wiggling, smiling dog. Perhaps after reading this book, you might agree (unless of course, you already do!). May the uncontainable happiness of these dogs touch your heart as much as they have touched mine.

—GRACE CHON

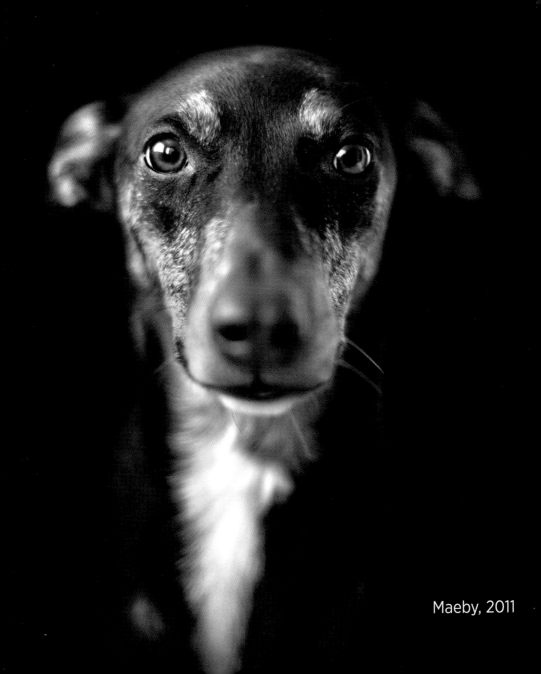
Maeby, 2011

There's no mistaking a happy dog. The busy tail and eager eyes, the smile that can't be faked, the unbridled excitement at watching you drag the trash cans to the curb each Tuesday. A happy dog radiates pure, palpable joy—and who can blame us for wanting in on it? Just being near them makes us feel good.

Yet the mystery remains, what's really going on behind those waggish grins? Are our dogs laughing with us? At us? At themselves? Are they operating at a higher stage of enlightenment . . . or just buttering us up before we discover the tiny, torn remnants of burrito wrapper suspiciously dotting the hallway to the den?

It's a subject we found worthy of further investigation. Not to mention a great excuse to meet and photograph some truly incredible dogs.

So armed with a camera and plenty of biscuits, we rounded up a world-class collection of canines— big and small, rescues and pure breeds, deep thinkers, bemused skeptics, and carefree optimists—and let their smiles speak for themselves. We hope they leave you smiling, too.

waggish

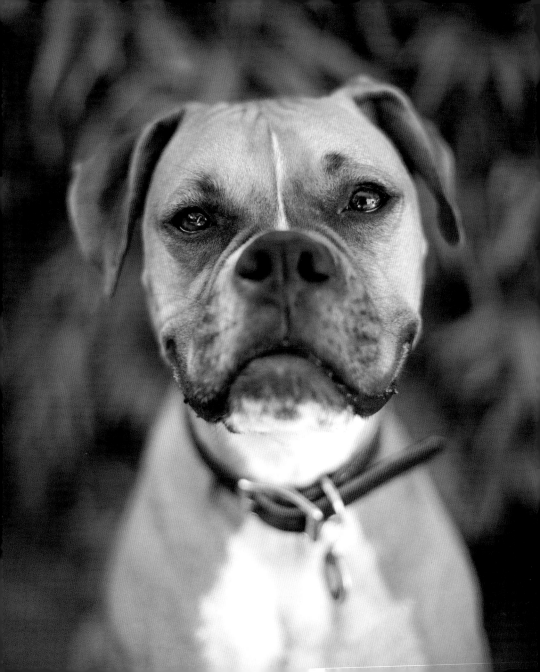

Whaddaya say you call in sick today and
we go chase some squirrels?

If loving tennis balls is wrong,
I don't want to be right.

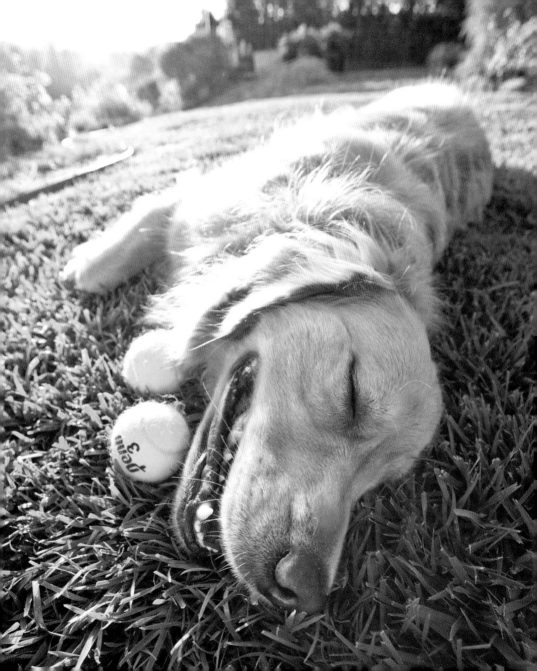

I just scared the crap out of
the UPS guy.

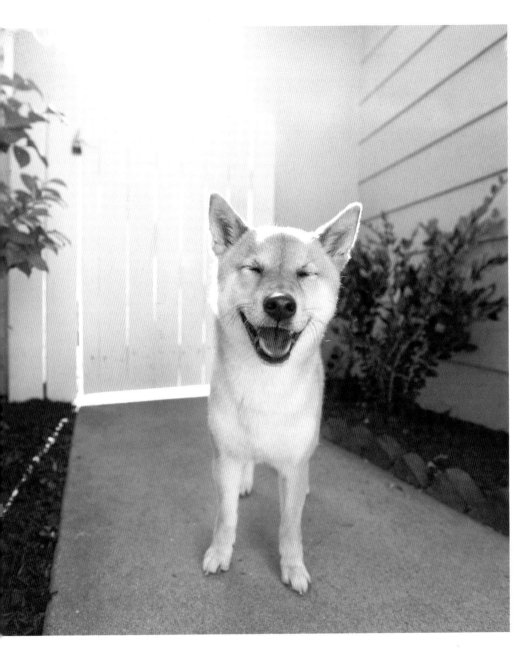

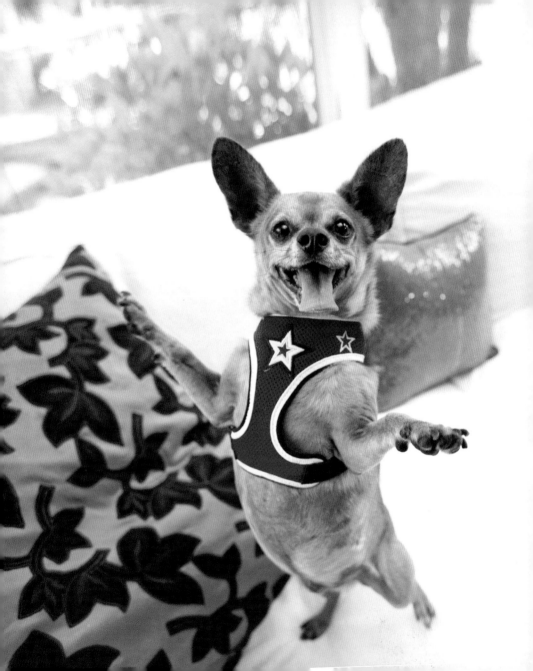

Somebody call a doctor,
I've got disco fever!

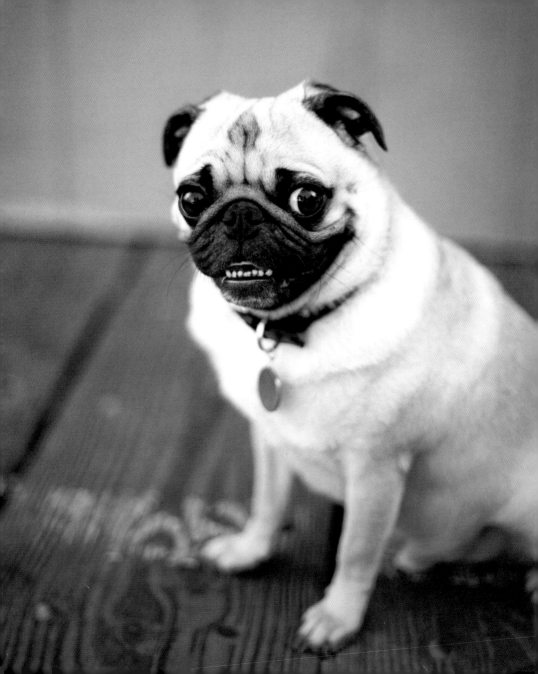

I farted, and this time I've totally outdone myself.

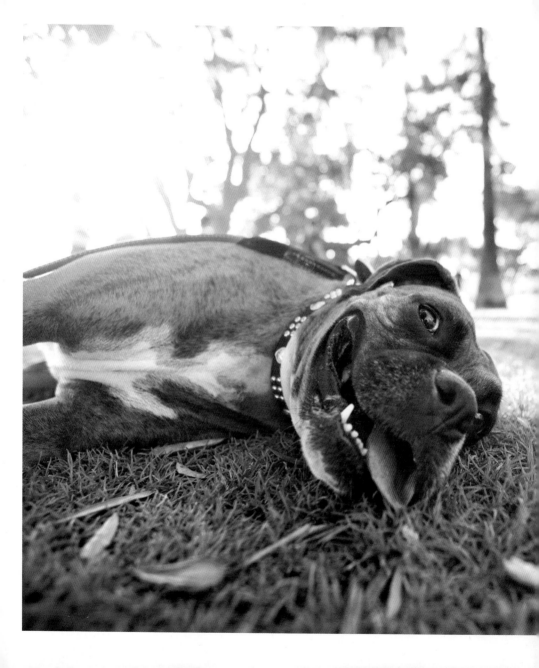

How about you go get the stick
this time and I wait here?

Oh, hi, you're home early! There's absolutely nothing going on upstairs—but before you come up, let's both pause and reflect on how much you love me.

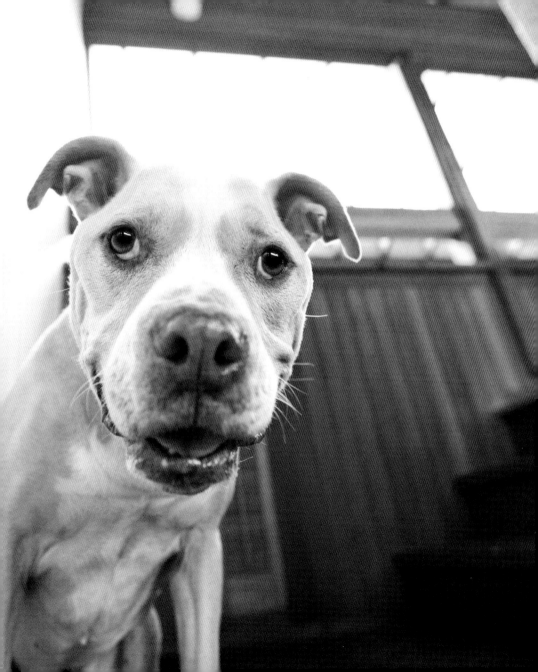

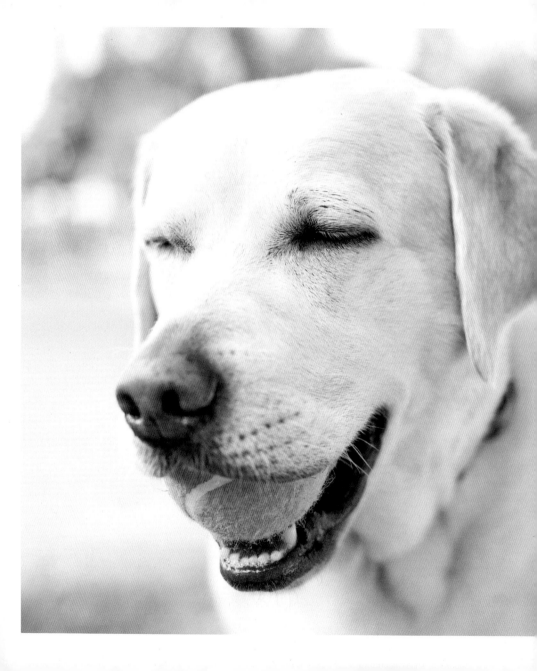

Ahhh, that new ball smell.

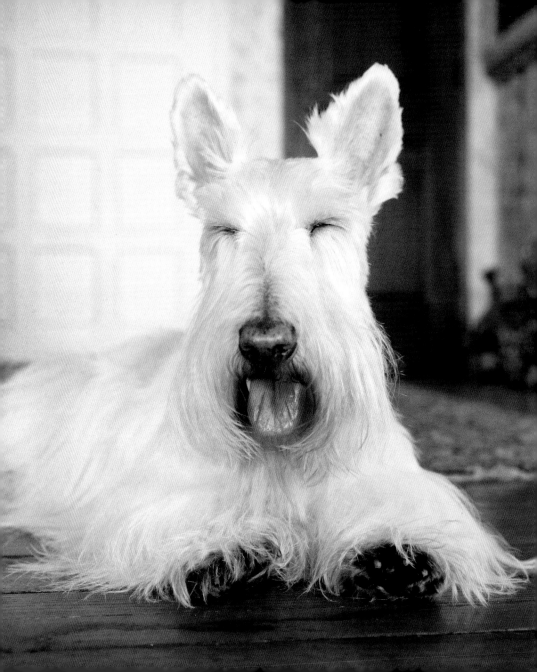

You'll never guess where I hid your underwear.

I know, right? I can't stand how cute I am either.

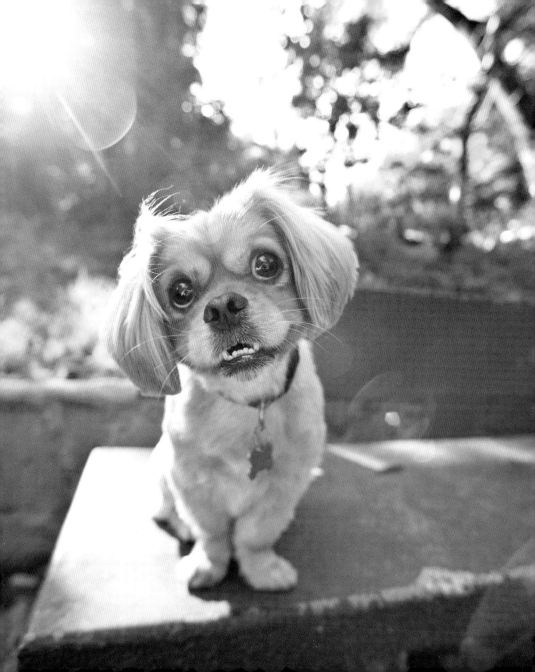

I'm smiling because you're smiling!

Why are we smiling?

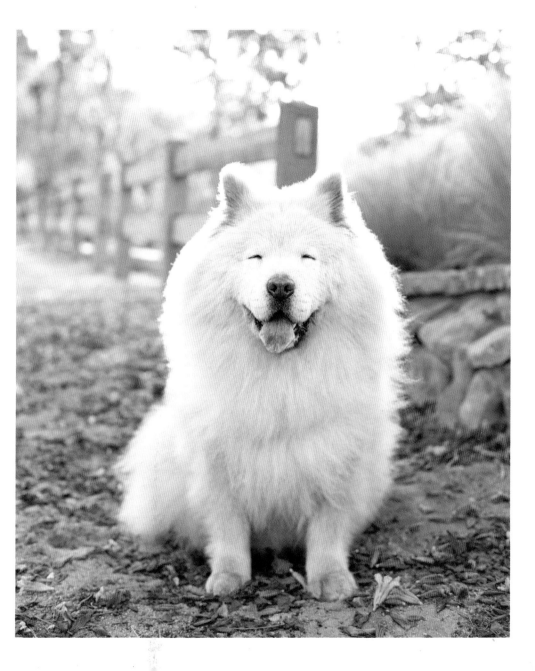

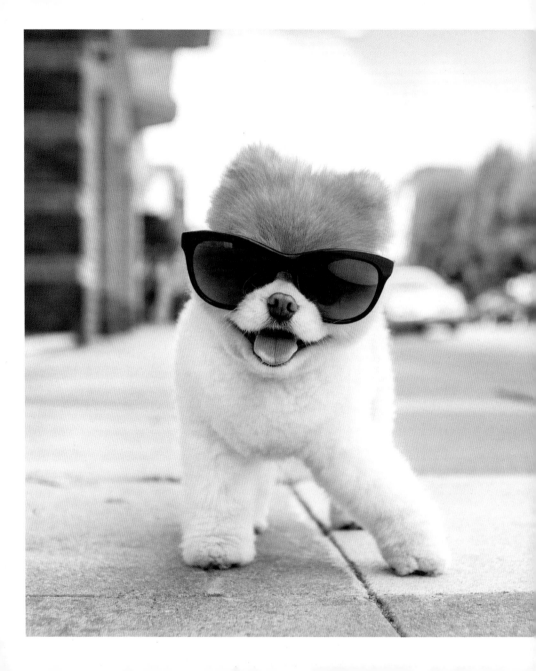

Shades on. Leg out. Head tilt.
Tongue ever-so-slightly forward.

Trust me, there's an art to this.

I smell pot roast.

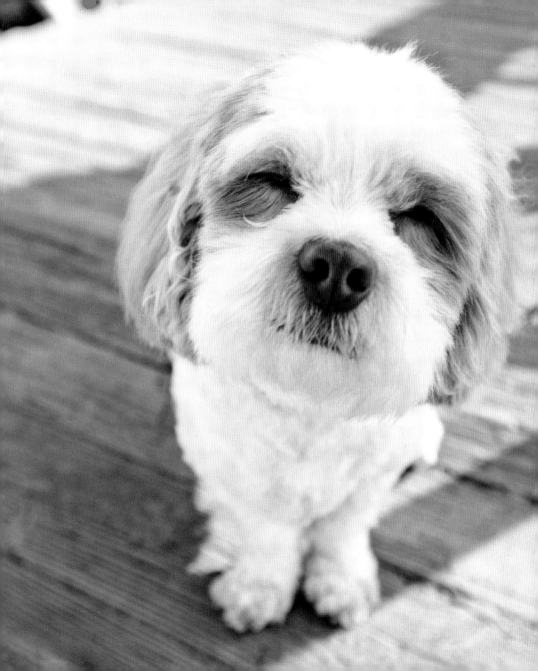

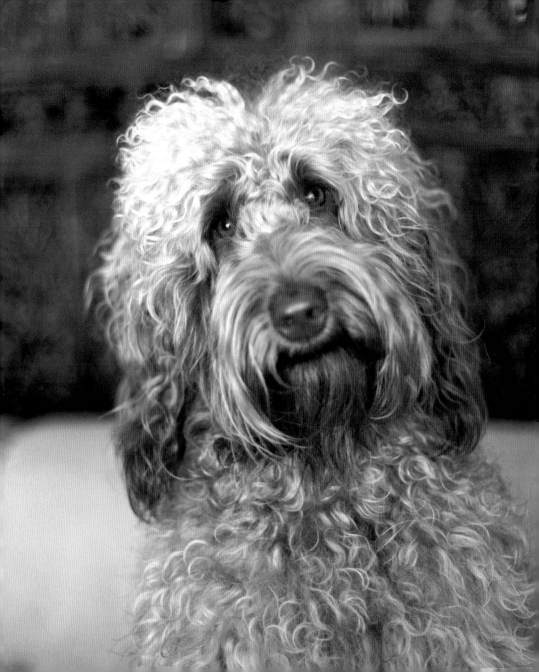

Yes, I know you can't work while I'm staring at you.
Why do you think I do it?

Hurry, take the picture—
I can't hold this pose forever!

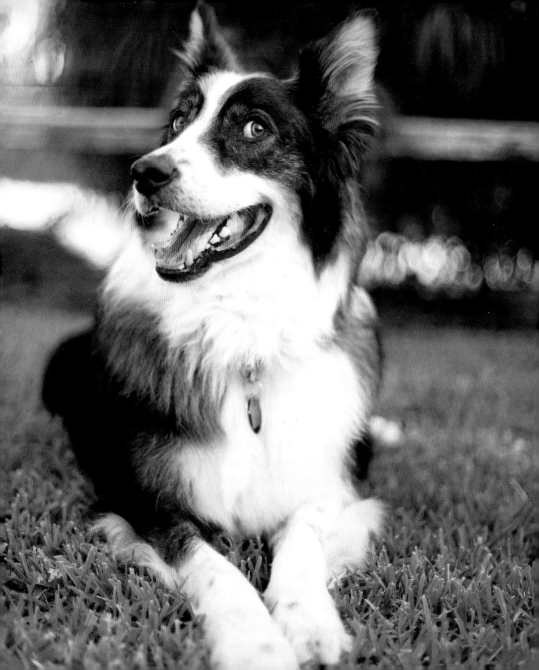

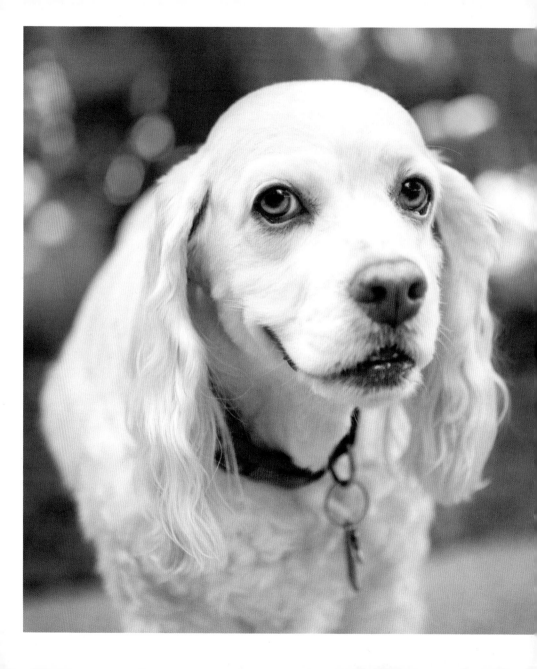

You had me at hot dog.

Will you let me in so I can go out again?

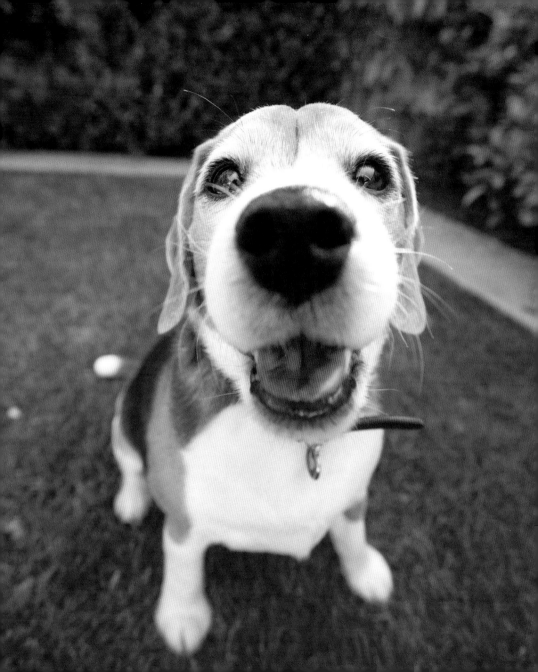

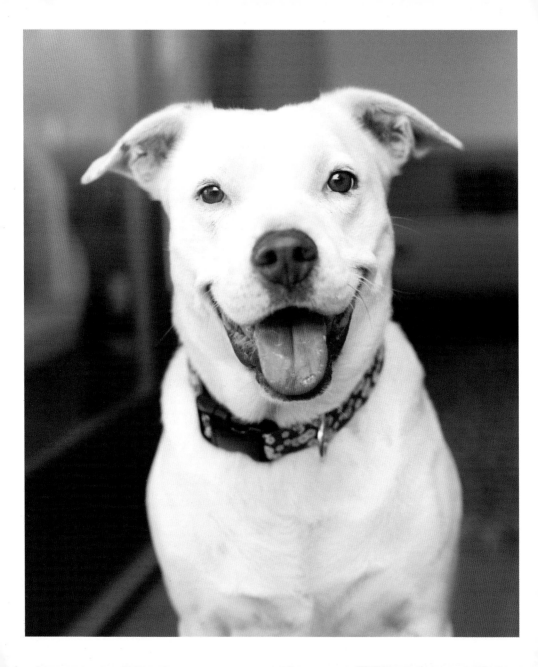

A walk? Let me just check my sched . . .
Yep, I'm good.

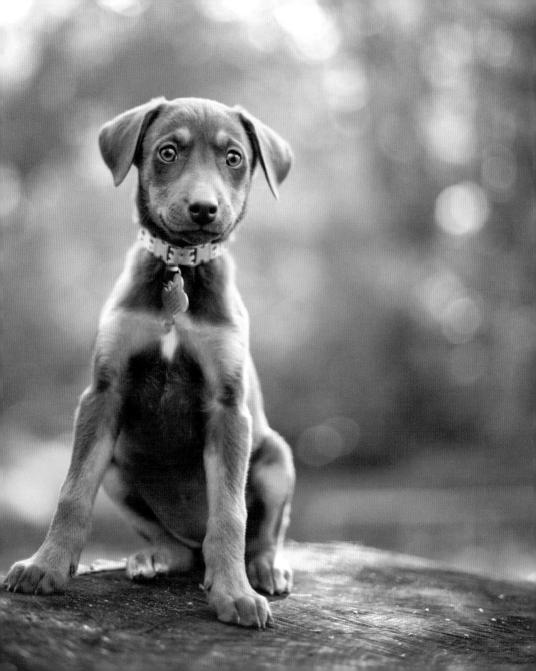

I just ate my own poop.

And I liked it.

I wonder if he thinks about me as much as I think about him?

I'm such a sucker for Rottweilers.

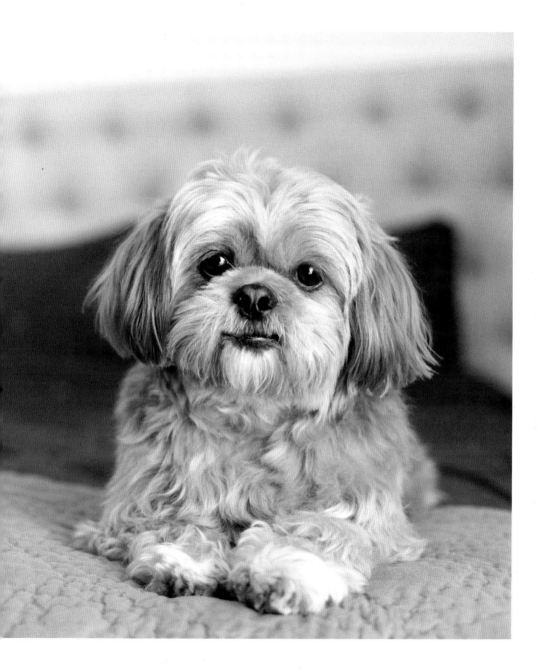

Hypothetically speaking,
let's say I *did* roll in that raccoon carcass . . .
exactly how bad would you freak out?

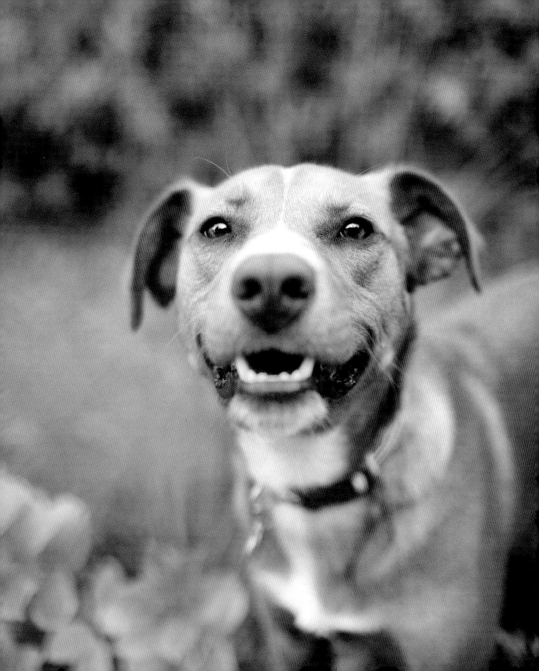

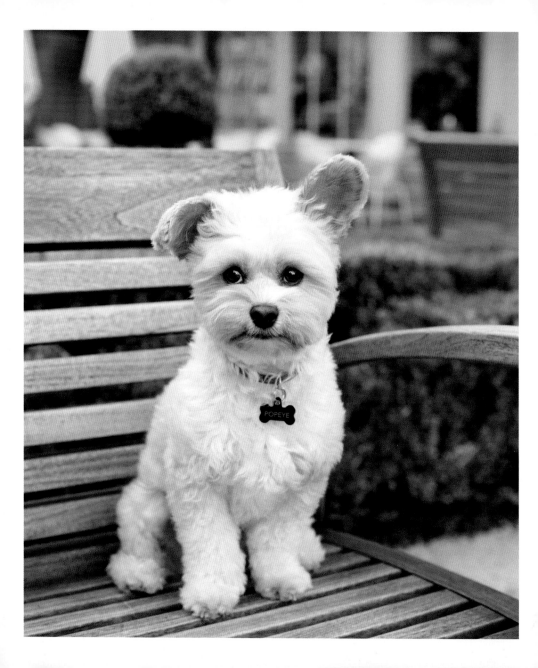

Yes, I'm aware I resemble a stuffed toy.
The comparison has been brought to my attention once
or a thousand times before.

Please, don't let me disturb you.
Enjoy your dinner.

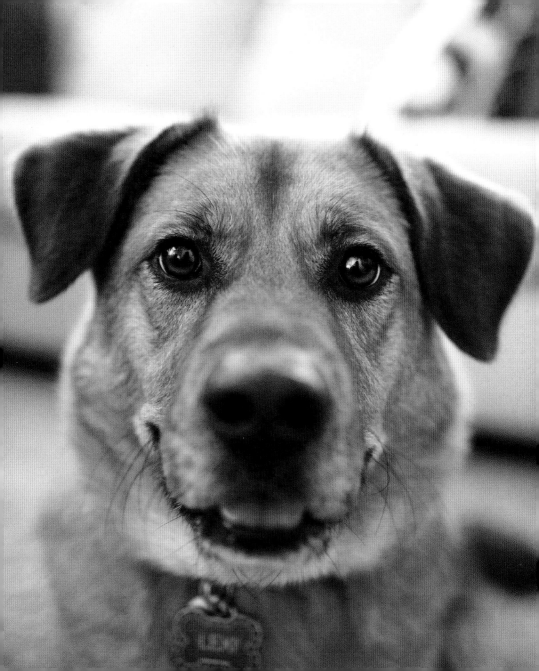

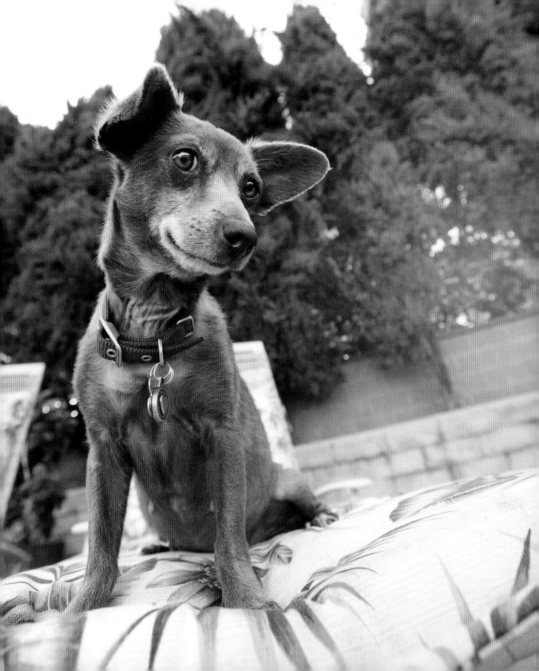

I'm all for a "lazy Sunday" but you might want to ease up on those margaritas if we're going walkies later.

Sure, I look poised and sophisticated now,
but five minutes ago I was dragging my butt across
the Persian rug.

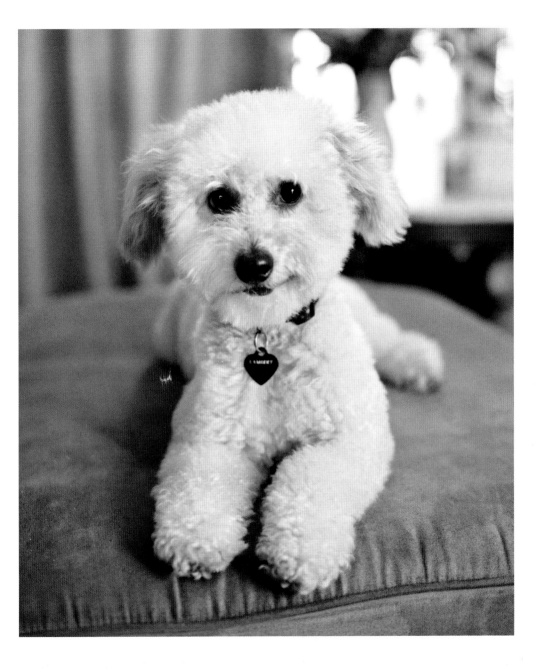

I don't usually eat dirt,
but the blend they've got going on
behind the left sprinkler here . . .
man, that's good stuff.

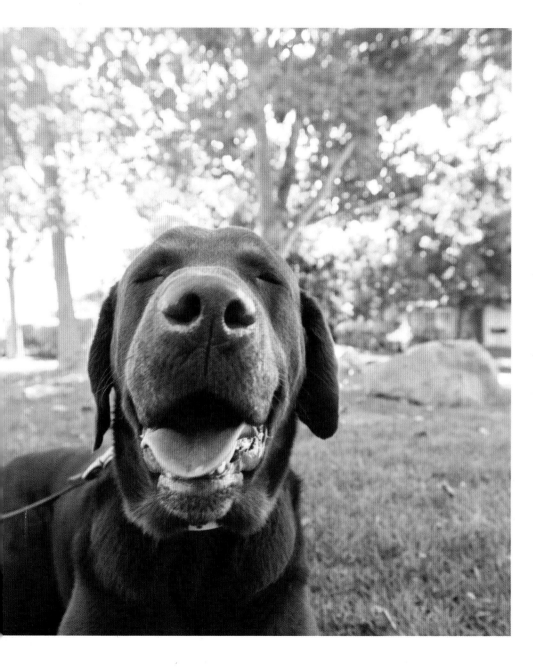

Here she comes.
Act innocent!

Relax, this ain't my first rodeo.

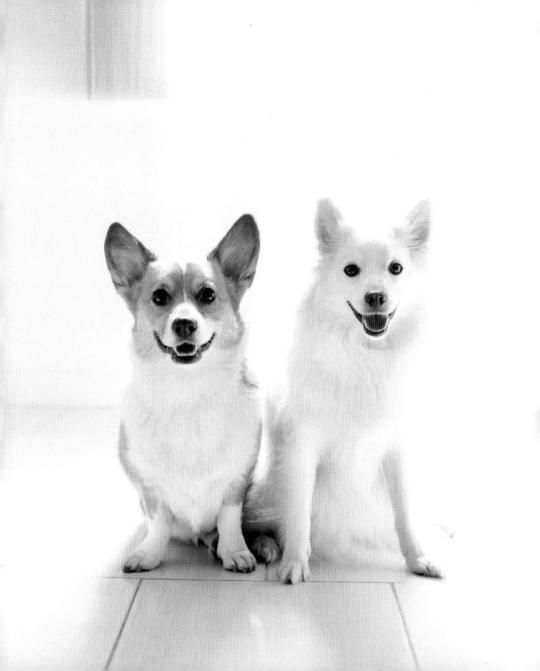

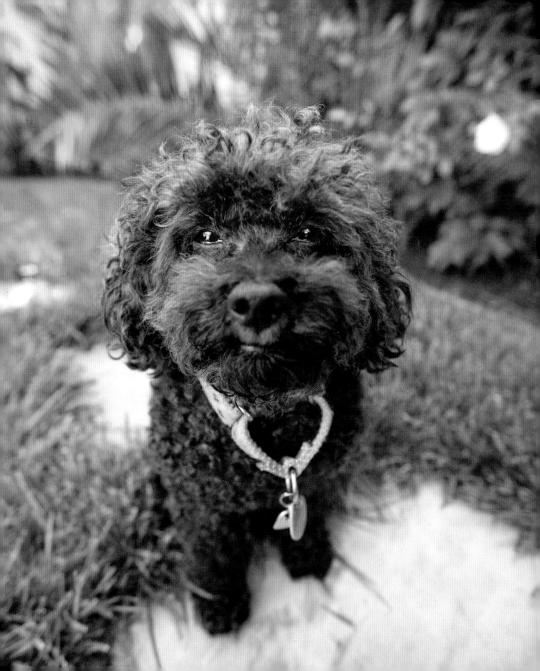

Before you come out here, be advised that
I've made a few renovations to the flower bed.

Hey, I just thought of a
great new game.
I sit here like this, and you
try to throw treats into
my mouth!

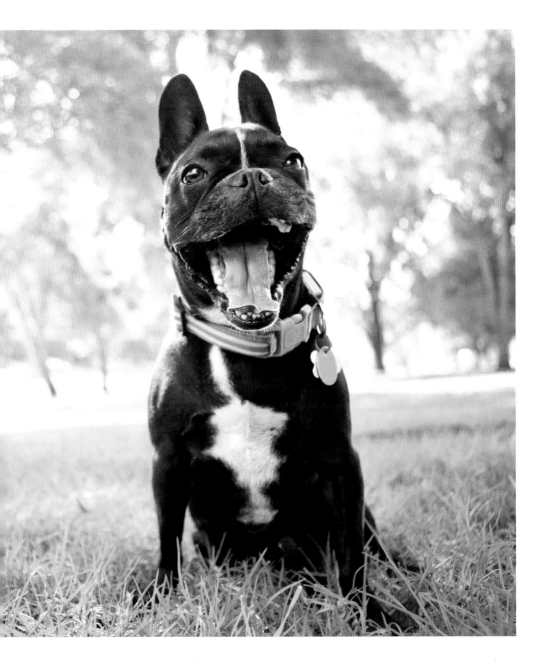

My nose, your business. Oh yes. It's happening.

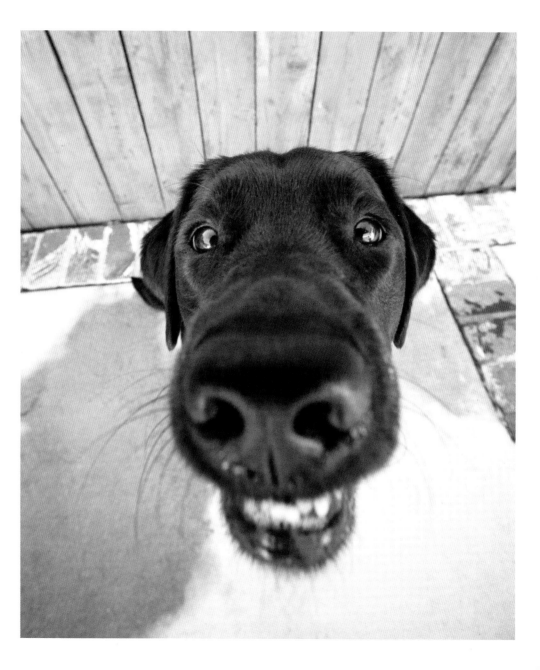

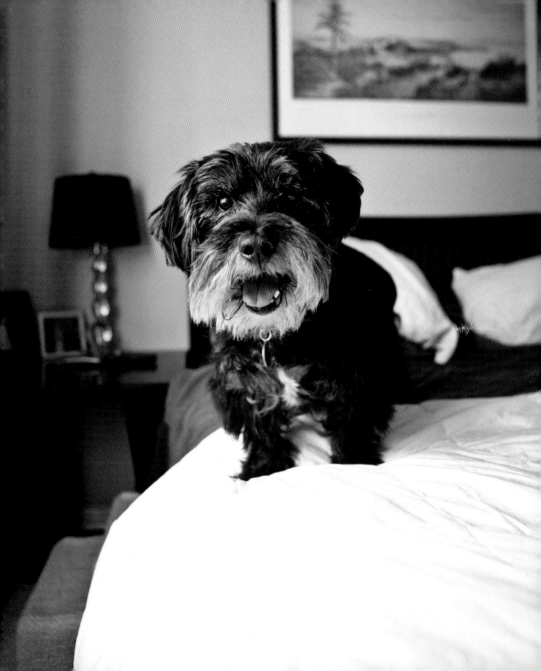

Oh, just remembering something
funny from yesterday.

Very funny.
Now please flip me back over.

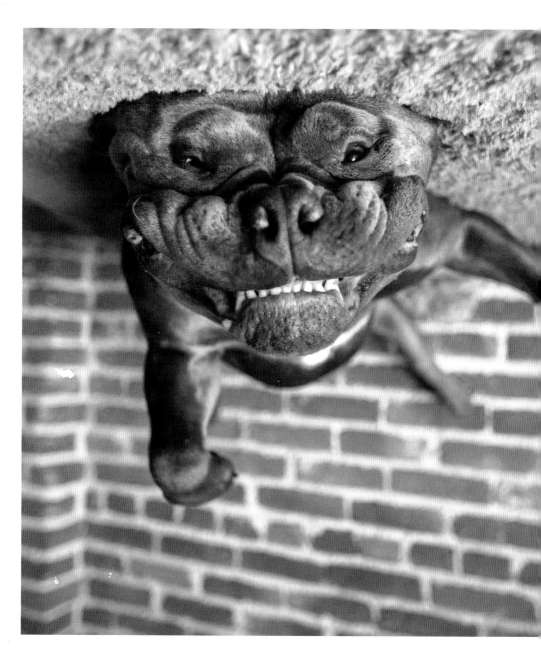

Will you be leaving for the office soon?
I've got a banana peel stashed under the bed
that I've been dying to play with.

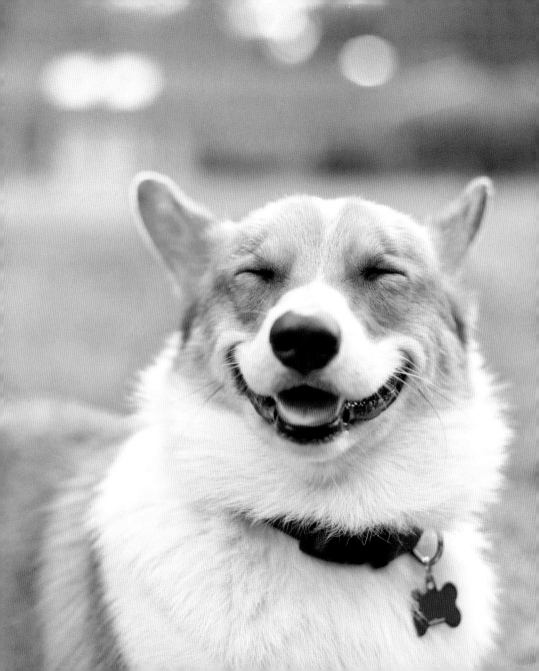

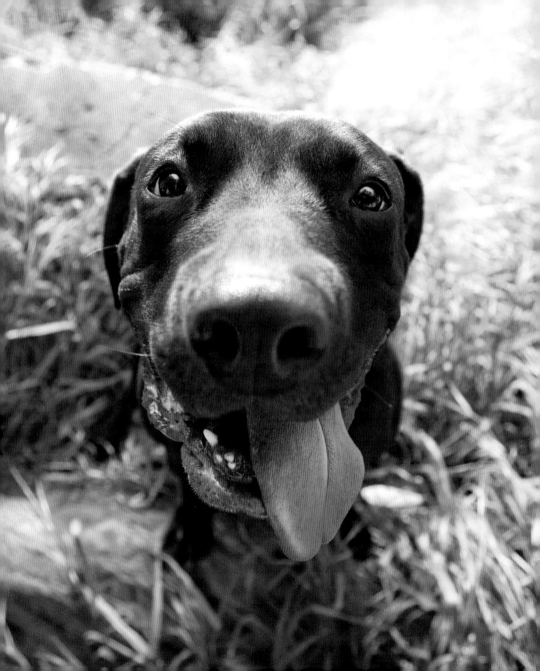

Kiss me, I have minty breath.
At least that's how it smells to me.

Sometimes I dream I'm in a book
and everyone can see me.

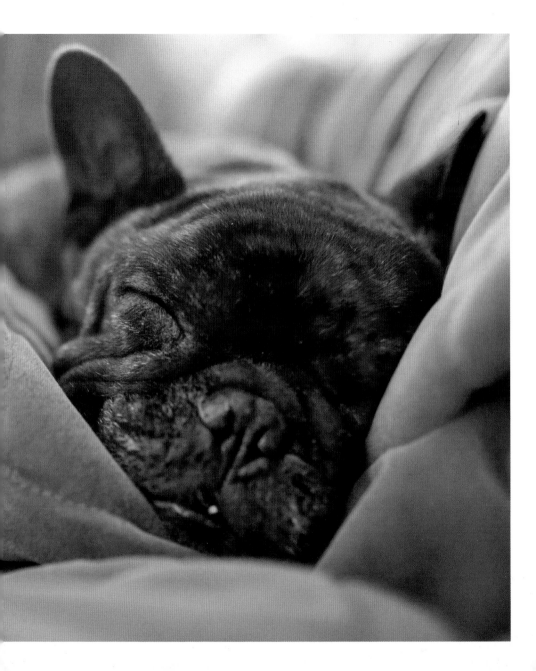

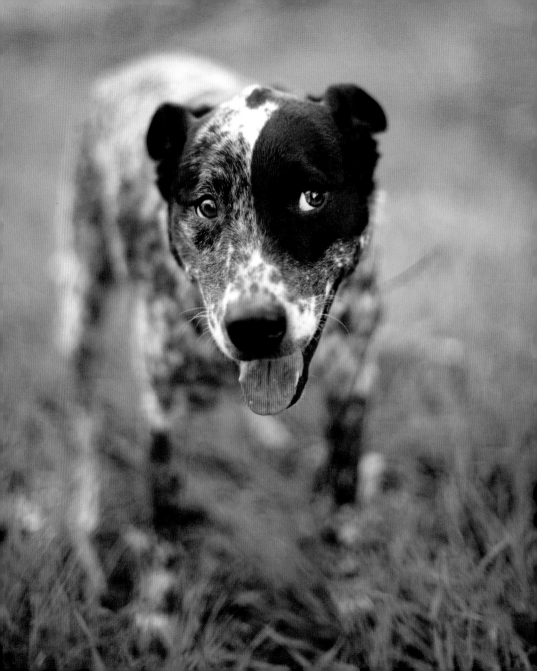

There's absolutely nothing going on here
that you need to worry about.

You appear totally unaware that
your fly is open.

This is going to make for an interesting
stroll to Starbucks.

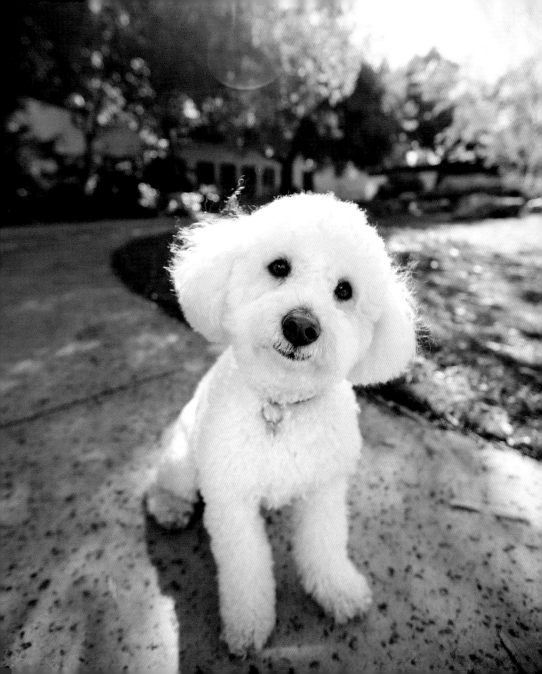

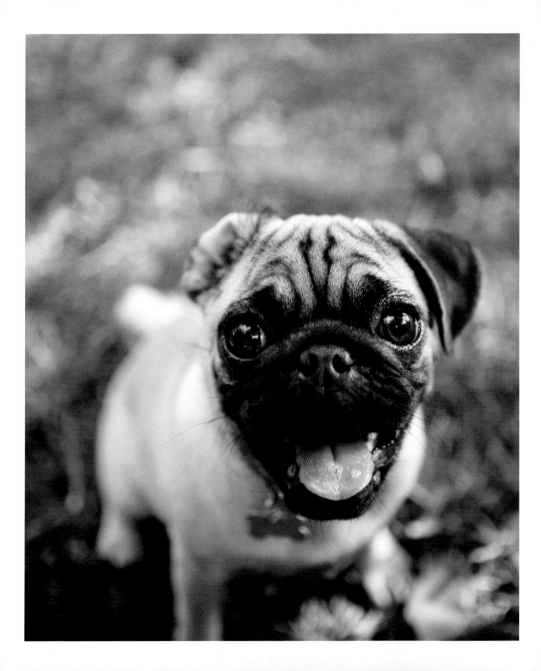

Can we stay five more minutes?

I'm gettin' my ya-yas out and I've still got one ya left.

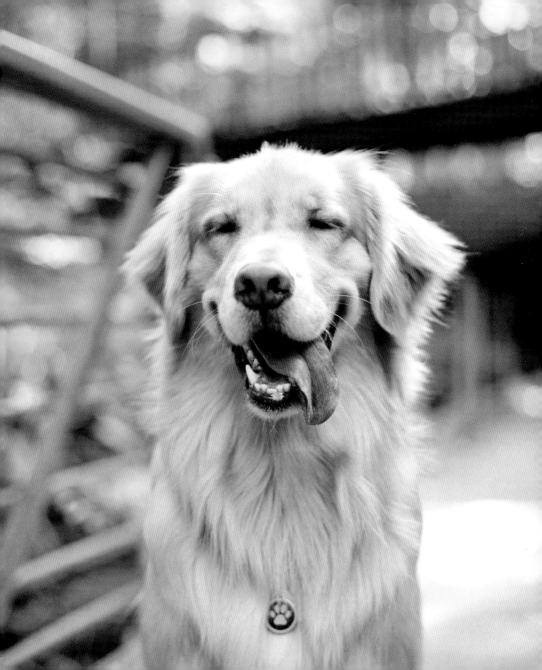

Duuuuude.

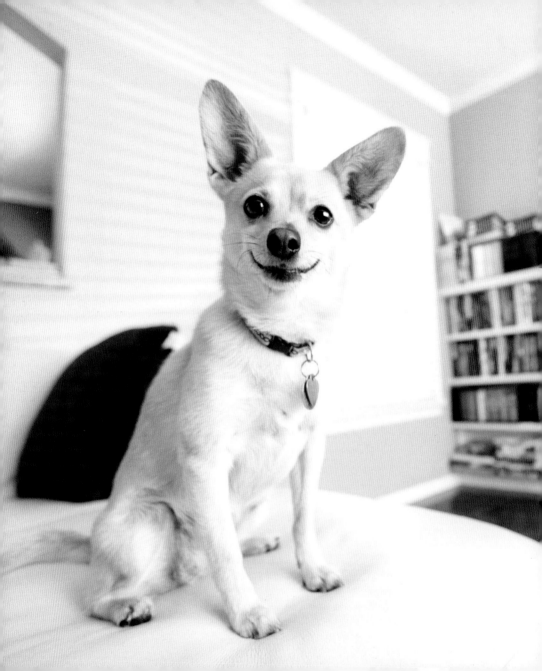

You know, we'll both get outside a lot quicker if you just forget the pants.

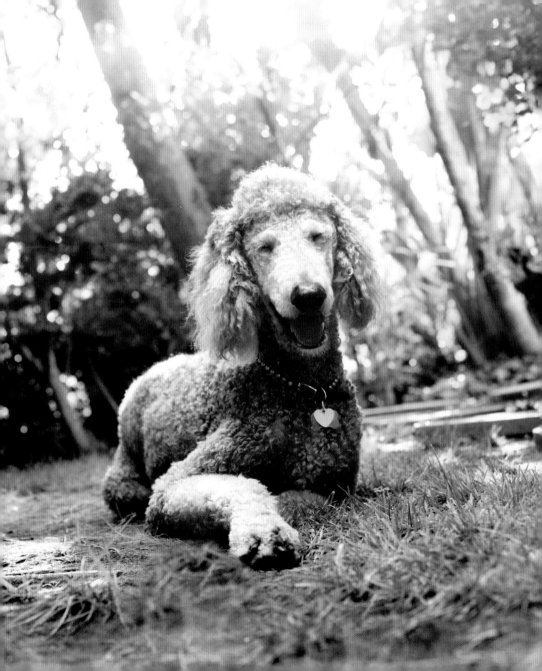

Ever hear the one about
the cat who swallowed a ball of yarn?

She had a litter of mittens!

I'm here all week.

Oh, *now* I get it!

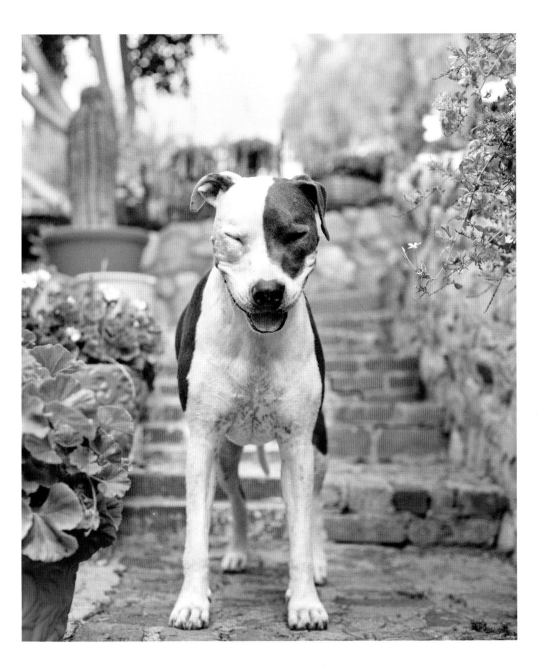

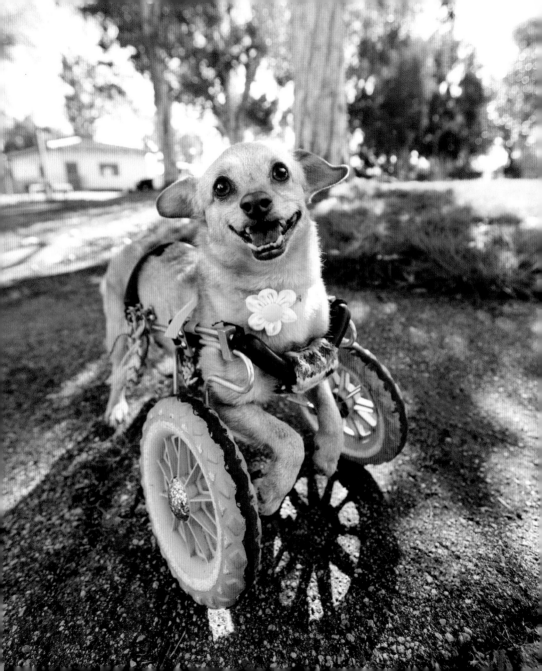

Is that the taco truck? Let's roll!

Hey . . . you have fur
inside your nose!

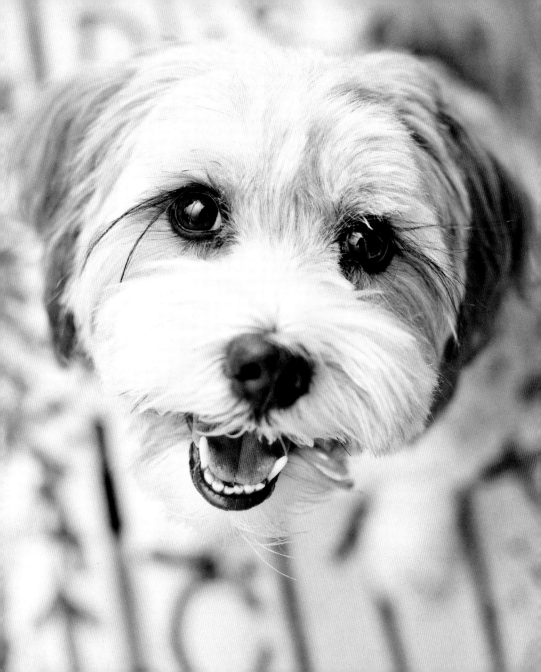

Oh, were you gonna sit here?

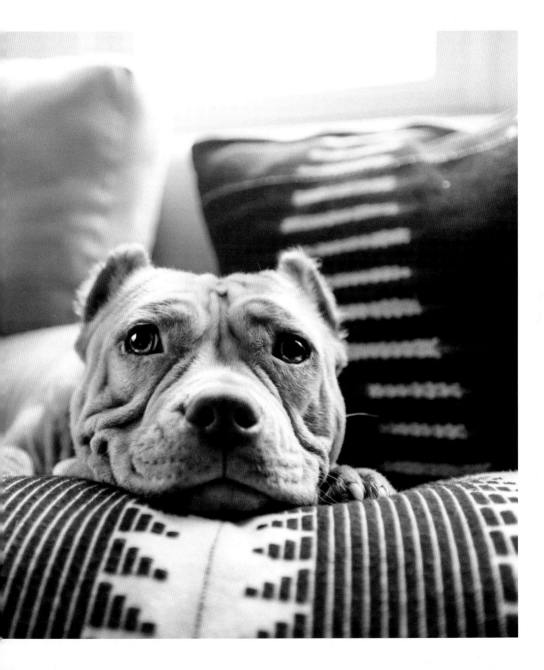

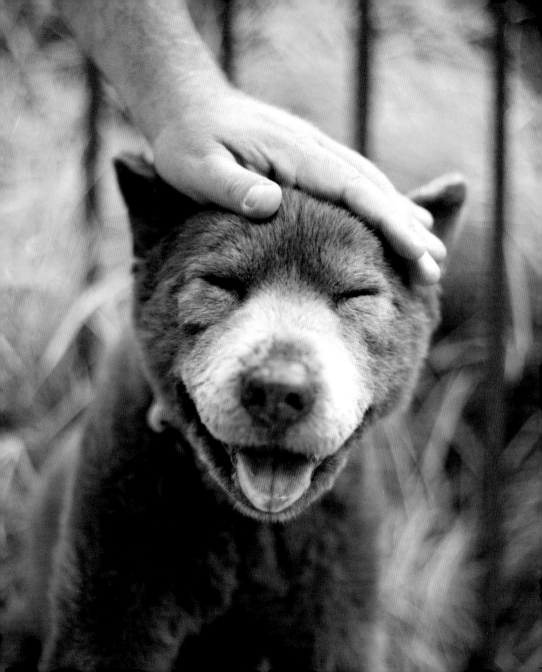

If I had a dollar for every time someone wanted to pet my fuzzy wuzzy head, I'd have, like, *so* many dollars.

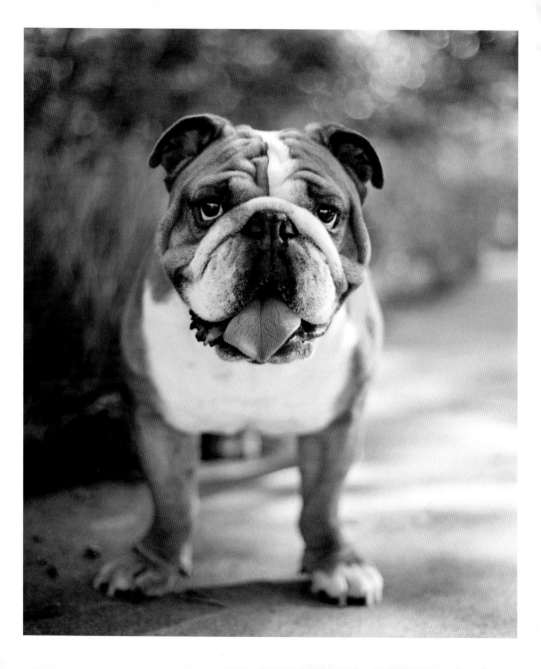

Just so you know, it would be
totally cool with me if you want to go home
and take a nap.

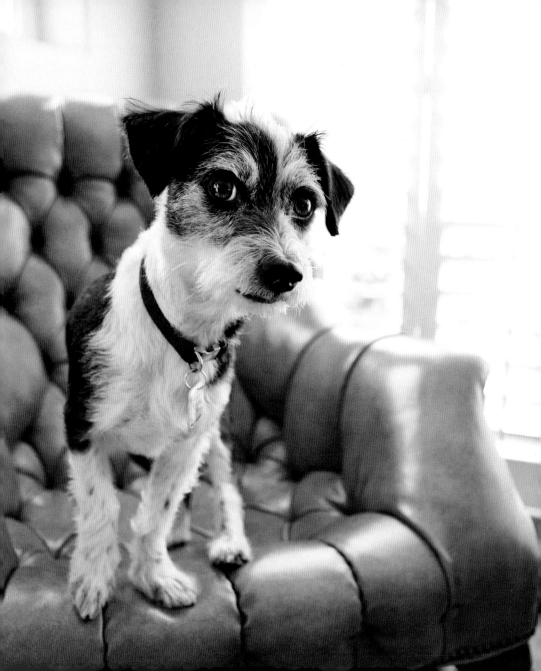

Are you a burglar?
Go away!

Oh wait, you brought bacon?
Please, come in.

I am aligned with the energy of abundance.
I give generously and receive graciously.
I am filled with gratitude and light.
I inhale deeply . . . and the scent of a thousand
distant cheeseburgers fills me with bliss.

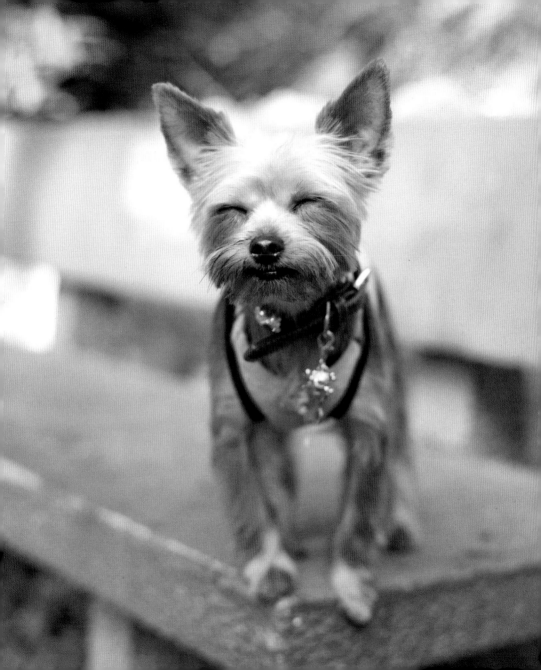

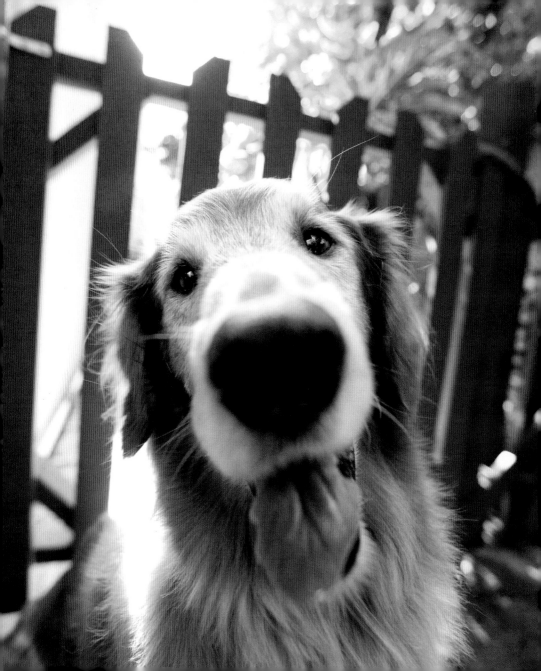

I'm so cute you want to squish my face off?
I appreciate the sentiment,
I'm just saying it sounds a little . . .
permanent.

I'm told my enthusiasm
is infectious.

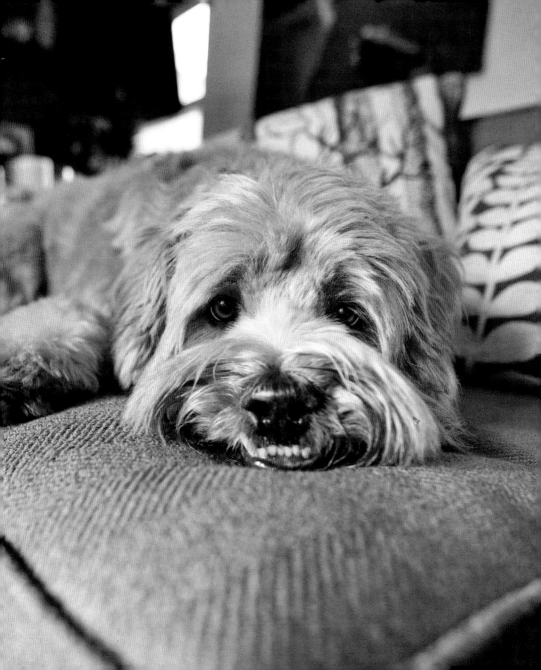

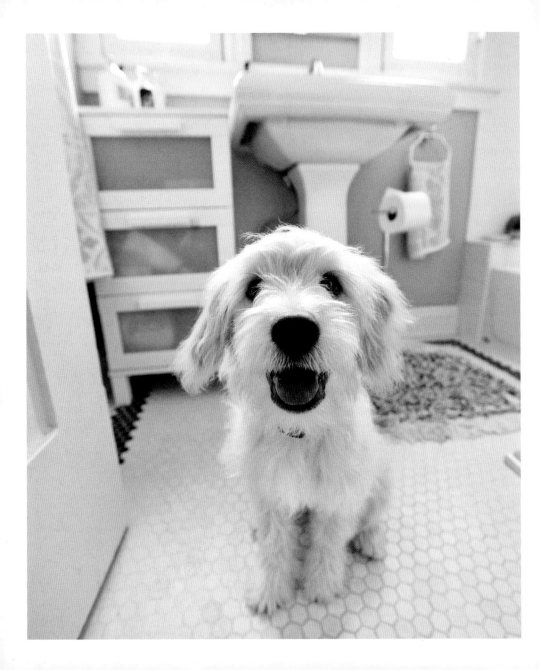

Wow, you've got no problem just letting it all hang out, do you?

Oh good, you brought sandwiches.

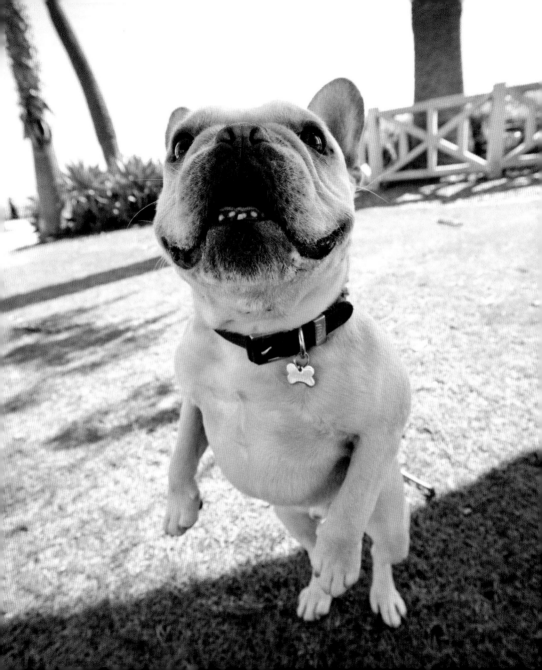

I'm all for going walkie-woo-woos, but can you just call it a walk while we're out in public?

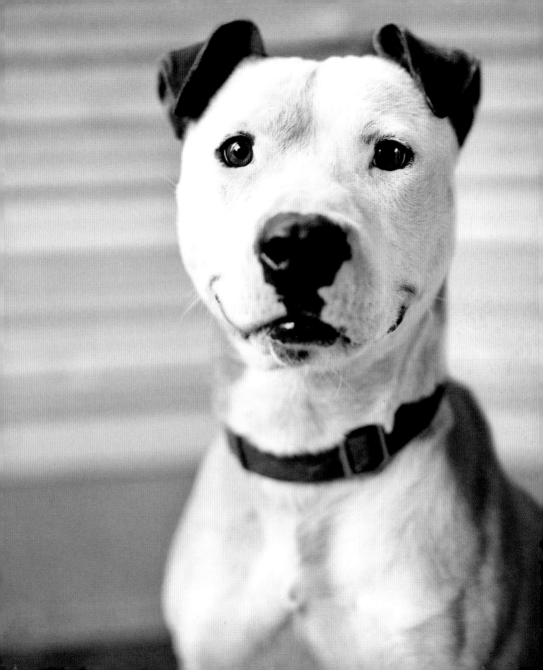

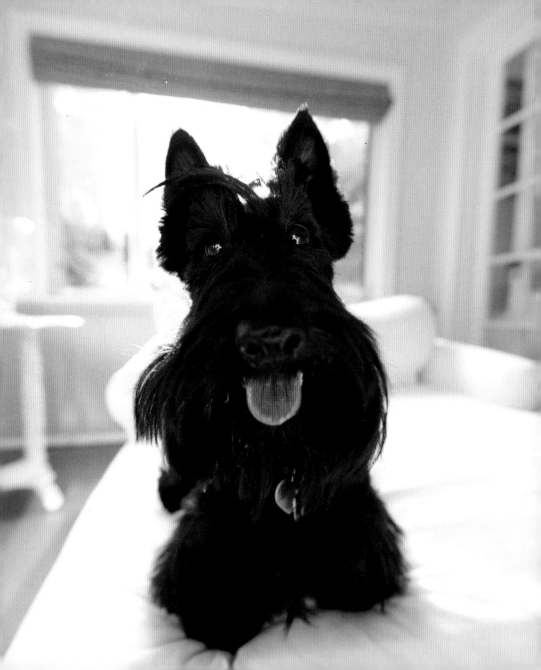

Now that you mention it,
I do recall you saying something about never,
ever jumping up on the couch.

That was the litter box?
I was just about to tell you how much I'm
enjoying the new kibble.

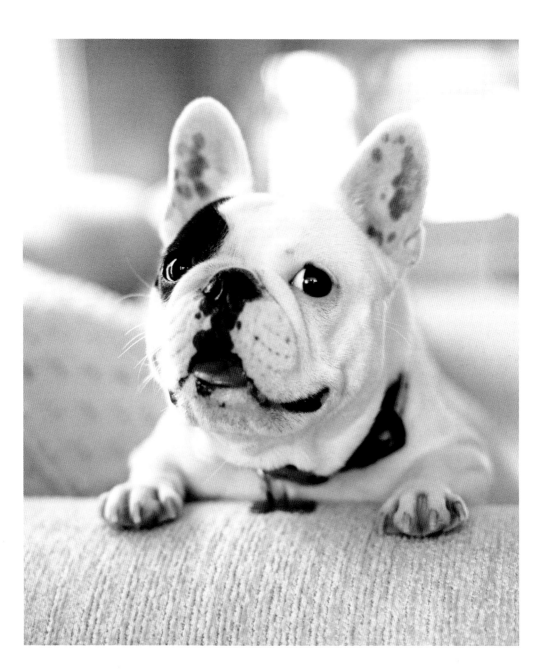

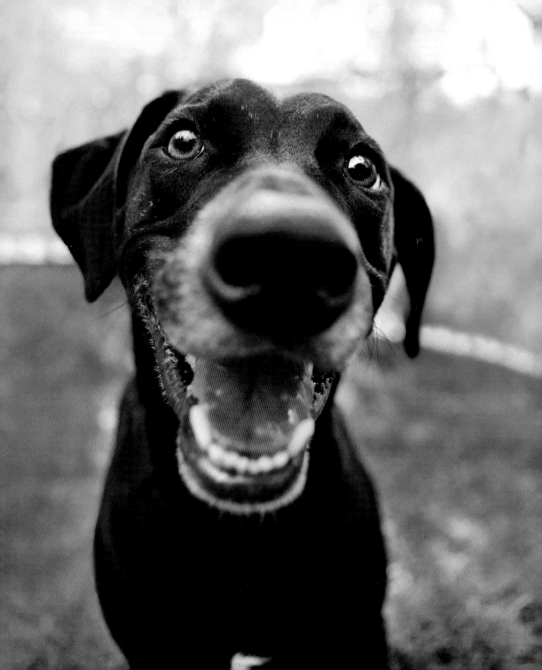

Let's end this silly charade—we both know you've got the ball behind your back.

Sure, tricks are fun, but let's face it—
I'm in it for the snacks.

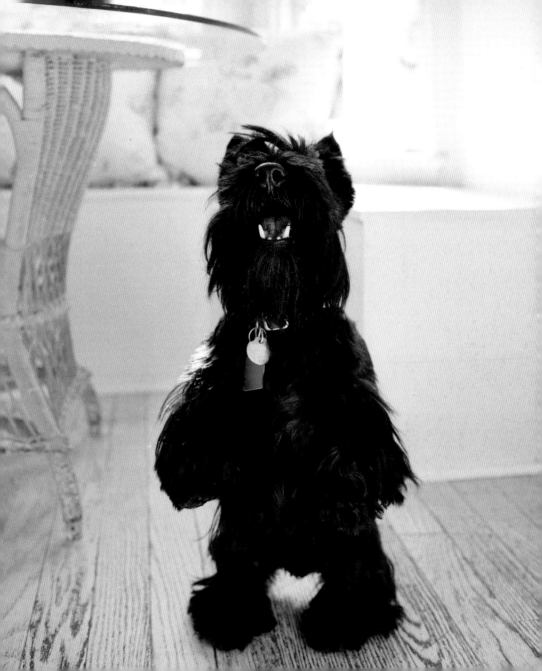

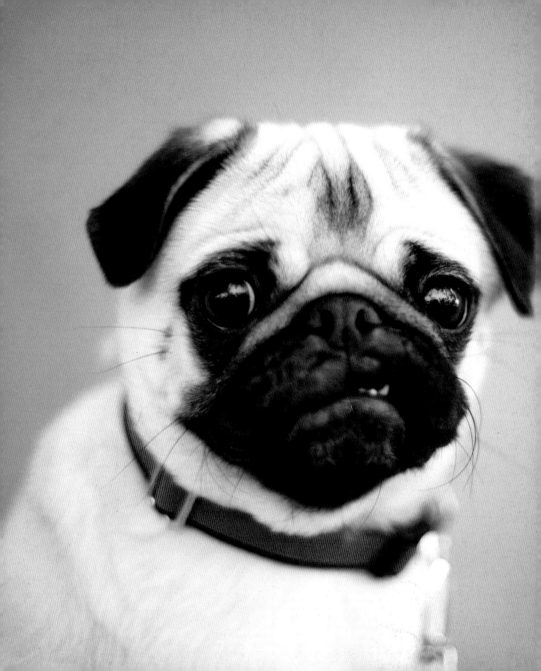

This is the face I make when
I blame the cat.

Of course, this is just my opinion,
but I believe they saved the best dog for last.

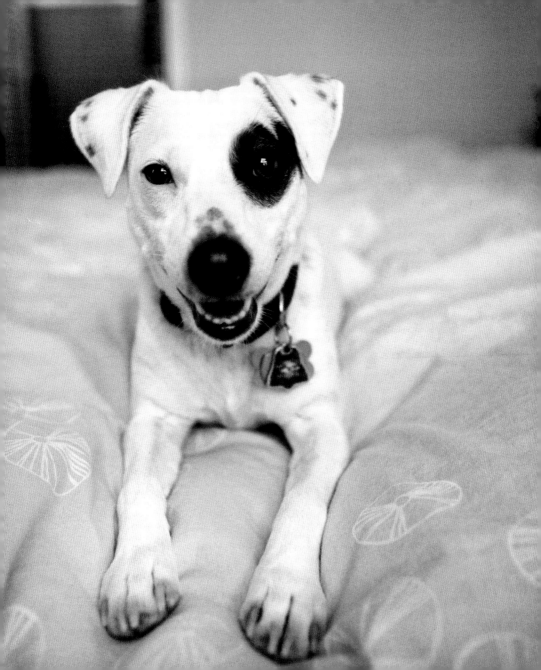

ABOUT THE DOGS

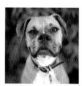 MACIE, Boxer

 IOLA, Boxer

 JACKSON, Golden Retriever

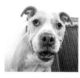 BINGO, Pit Bull mix

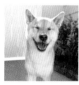 NALU, Shiba Inu

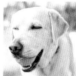 TAIGA, Yellow Labrador

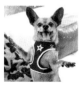 CHICO, Chihuahua

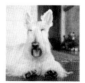 TRIPLE, Scottish Terrier

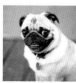 BUDDY, Pug

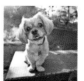 BAILEY, Cavalier/Pekingese mix
Instagram: @BaileyPK_18

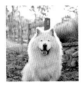 SASHA, Chow Chow

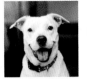 LUNA, Pit Bull mix
Instagram: @lunathesweetdog

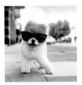 BOO, Pomeranian
Instagram:
@buddyboowaggytails

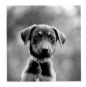 HONEY, Doberman mix

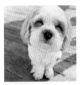 TREVI, Terrier mix

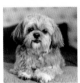 CHEWY, Shih Tzu mix
Instagram: @chewy_cho

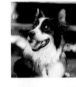 BRUMBY, Labradoodle

 HANK, Pit Bull mix
Instagram:
@hankthetanktakesla

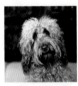 MARK, Australian Shepherd

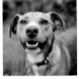 POPEYE, Mystery mutt
Instagram: @popeyethefoodie

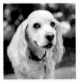 BBO BBO, Cocker Spaniel

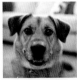 LEXI, Proud mutt
Instagram: @lexithepupski

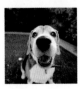 COOPER, Beagle

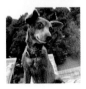 CHARLEY, Chihuahua Terrier

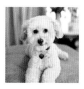

LAMBERT, Poodle mix
Instagram: @lambertdudley

SHERMAN, Mastiff/American
Bulldog mix
Instagram: @mightysherman

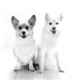

KODA, Chocolate Lab
Instagram:
@rufflife_of_kodabear_foxie

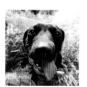

COLA, Corgi
Instagram: @colathecorgi

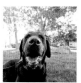

CHIBI AND KOKORO, Corgi and
American Eskimo
Instagram: @emwng

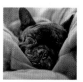

TIMMY, Pit Bull

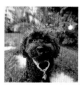

BLUE, Miniature Poodle mix

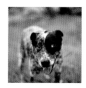

BEAR, French Bulldog
Instagram:
@bearthefrenchiebulldog

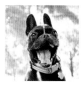

OLIVE, Frenchie/Boston Terrier
Instagram: @stuffdogslike

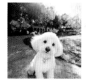

LULU, Cattle Dog/Border Collie

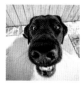

NAVI, Black Labrador

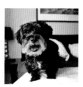

MIKIMOTO, Bichon/Poodle mix

HENRY, Terrier mix

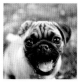

JUNO, Pug
Instagram: @junototherescue

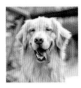 CHASE, Golden Retriever
Instagram: @chasethegold

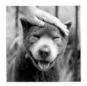 MAMA BEAR, Chow Chow mix

 COCO, Pomeranian/Chihuahua

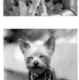 MANDOO, Bulldog

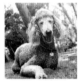 IZZY, Standard Poodle

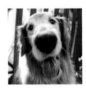 SMUDGE, Terrier mix

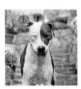 SHAMA, American Staffordshire Terrier

 MAX, Yorkie

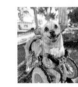 DAISY, Chiweenie/Terrier mix
Instagram: @underbiteunite

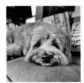 MEADOW, Golden Retriever

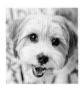 LUCY, Tibetan Terrier
Instagram: @thislucymuppet

CHACHI, Poodle/Sheepdog mix

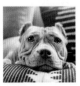 SHORTCAKE, Bulldog/Pit Bull/
Sharpei mix
Instagram: @theladyshortcake

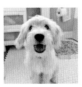 LONDON, Mini Goldendoodle
Instagram: @londonsdoodles

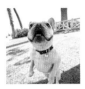 BING, French Bulldog

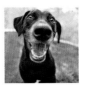 KAI, Costa Rican street dog

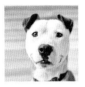 SUNSHINE, Pit Bull

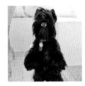 THOM, Scottish Terrier

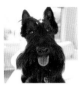 MAGGIE, Scottish Terrier

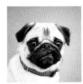 KIKI, Pug

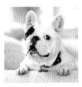 LOULOU, French Bulldog
Instagram: @louloulafrenchie

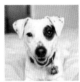 NAPA, Jack Russell Parsons

ACKNOWLEDGMENTS

This book wouldn't have been possible without you, Vin. Thanks for being my rock and my best friend. Thank you, Jasper, for being mommy's ball of chaos, joy, and inspiration every single day. Thank you to my mom, Carol, for cheering me on even when I didn't grow up to be a pharmacist. A huge thank you to our editor, Ann Treistman, for believing in my work, and to the amazing team at Countryman Press. Thank you, Melanie, for being the best writing partner a gal could ask for—I'm completely out of fart jokes now. Special thanks to all the friends I randomly texted for focus groups. You know who you are. Most of all, thank you to all the dogs and their people that have sat in front of my camera over the years. I couldn't have created this book without you.

—GC

The greatest thing I've ever done as a writer was to marry a better writer. Thank you, Mark Monteiro, for being my live-in editor and for your insight, contributions, humor, sanity, big ideas, and delicious slow-cooker meals. Thank you to our amazing editor, Ann Treistman, and the wonderful team at Countryman Press. Special thanks to talented friends Steve Nash, Tina Morasco, and Marni Burns, and to my dog-loving family and friends for thoughtfully weighing in on all manner of poop jokes. Finally, thank you to dog photog-rockstar and friend, Grace Chon, for inviting me onboard. How fun was this?!

—MM

ABOUT US

GRACE CHON is a commercial and editorial animal photographer, recognized for her highly expressive portraits of animals. Her clients include ad agencies, pet brands, magazines, publishing companies, celebrities, and TV shows. Grace has been photographing animals for the last 10 years, but before she stumbled upon the greatest job in the world, she was an art director in advertising. See more of Grace's work at www.gracechon.com.

MELANIE MONTEIRO is a writer, pet lifestyle expert, and author of *The Safe Dog Handbook*, inspired by her adventures with Taiga, the world's most accident-prone puppy. She hosts The Safe Dog Channel on YouTube and works with brands, pet professionals, and pet owners to promote healthy, happy living with pets. Before going to the dogs, she spent 15 years as a writer for ad agencies in Los Angeles. Visit Melanie at www.thesafedog.com.